W9-BAH-615

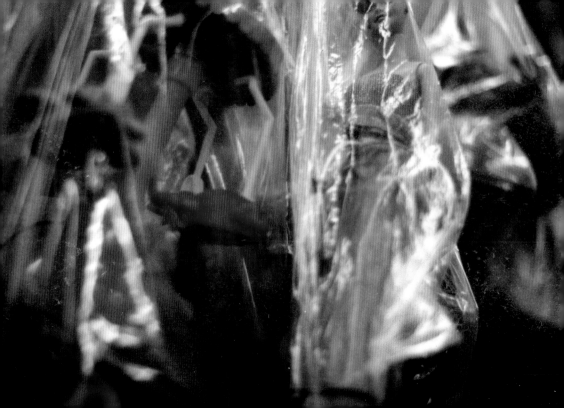

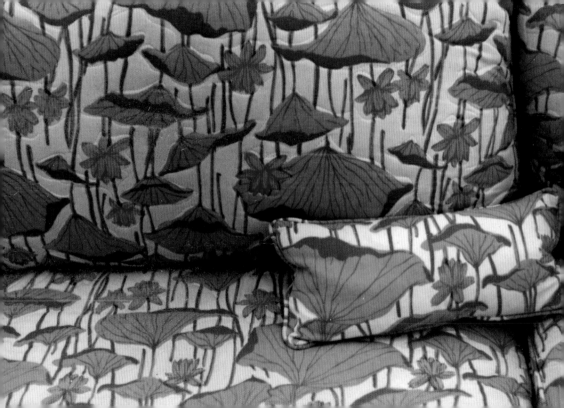

Thrift Store

THE PAST & FUTURE SECRET LIVES *of* THINGS

Emily K. Larned

BROOKLYN, NY

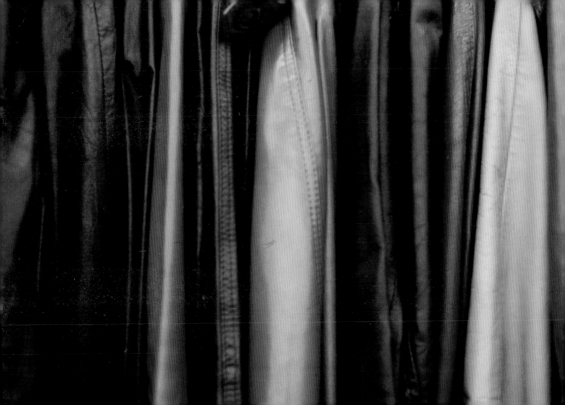

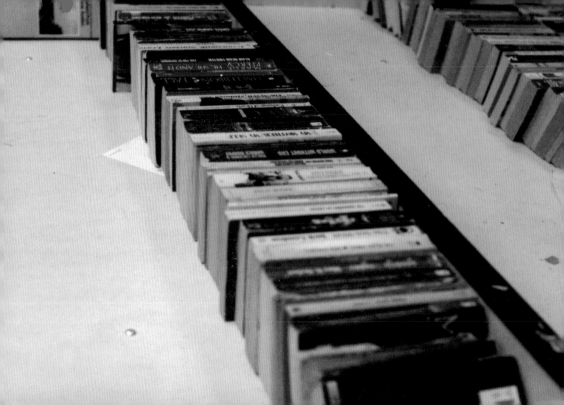

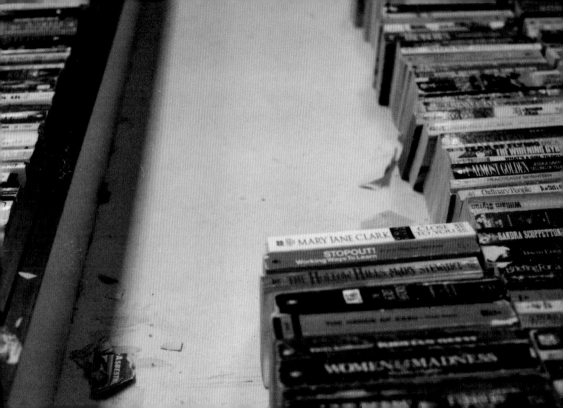

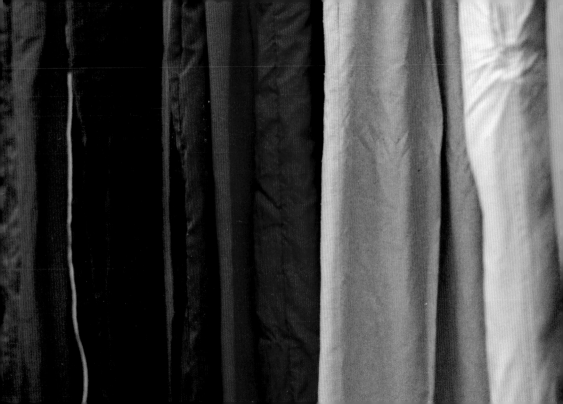

————————————

One thing aside another, things grouped together by likenesses: racks and racks in rows and rows of blouses arranged by color, sleeve length, fabrication, and style. Books organized by subject or by size, by color or by content, rows and rows of books and books. Records and more records, hundreds of pounds of records. Shoes pair by pair, those of ladies and men and children and babies. Coats, sweaters, shorts, plates, suitcases, skirts, all piled or stacked or shelved or hung with their own kind.

But then, inevitable entropy: a stuffed animal next to spatulas, a nightgown with the dress shirts, a tennis racket surrounded by picture frames, a toddler's sweater among ladies' slacks. A ball gown thrown among the bedding and the blankets. Shelves and shelves of kitchen utensils, lamps, personalized mugs, possibly broken appliances, a whole corner of reclining chairs, a congregation of obsolete computers, complimentary vases from florists, unused used-up wedding presents.

Whatever you start with, it does not stay that way: disuse swallows use as easily as disorder, order.

Emily K. Larned

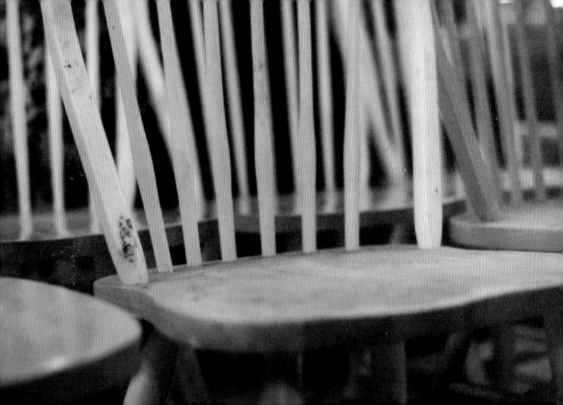

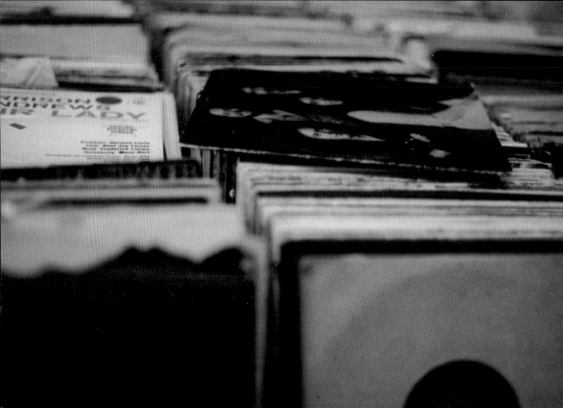

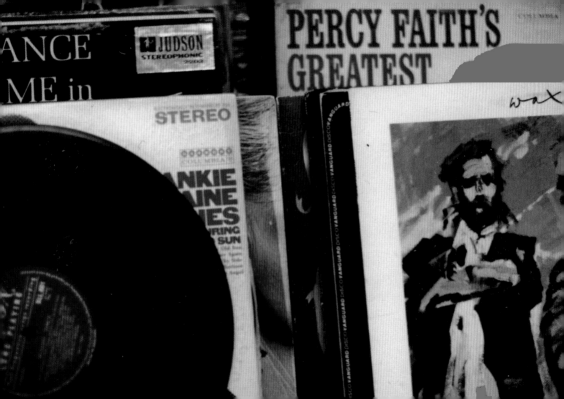

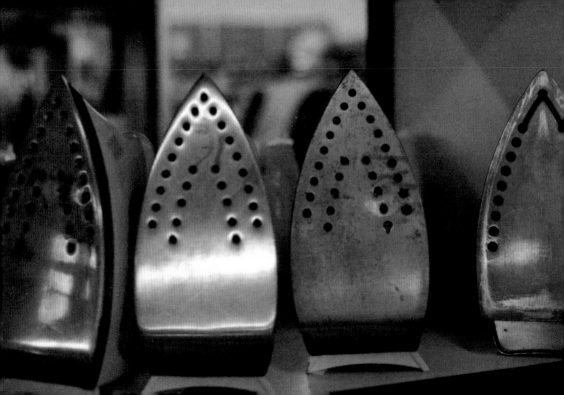

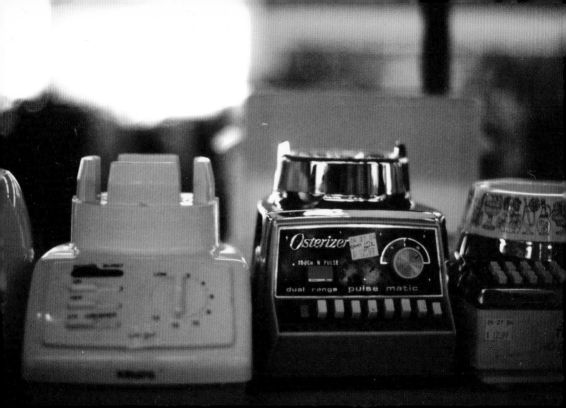

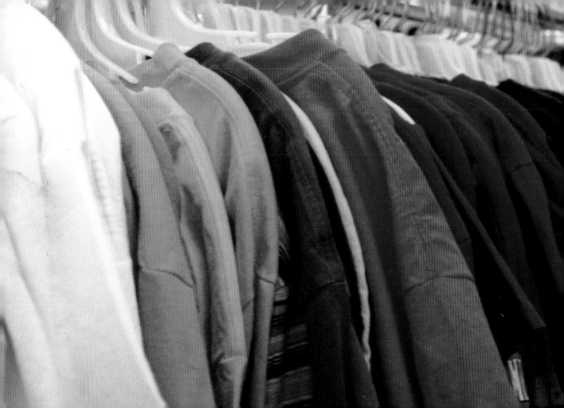

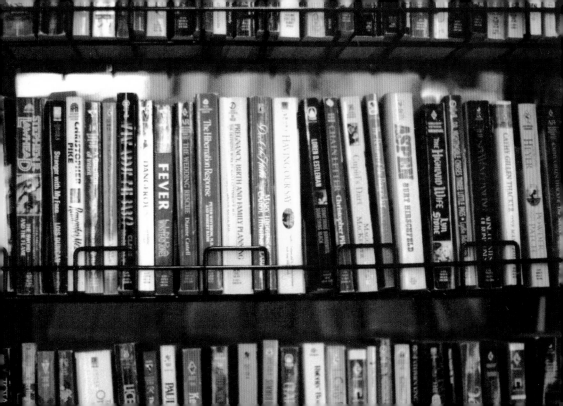

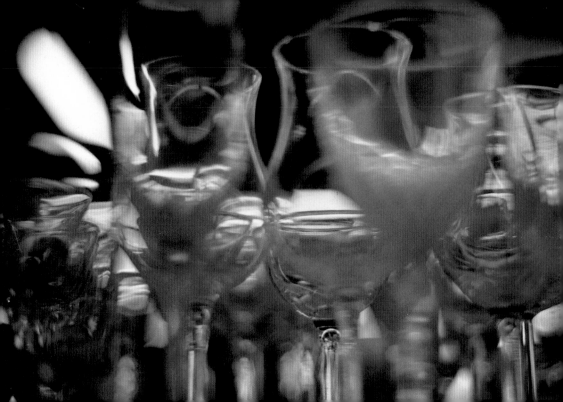

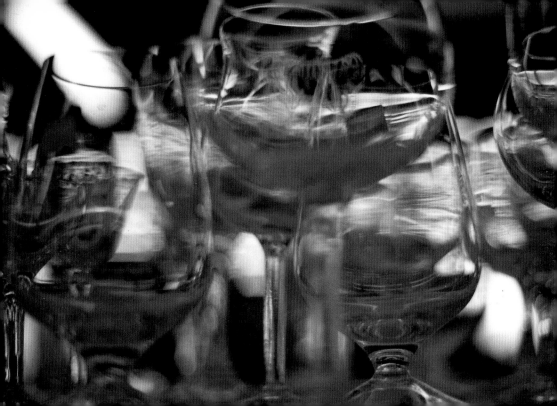

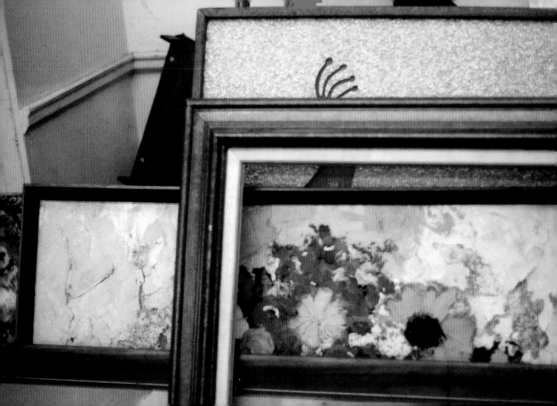

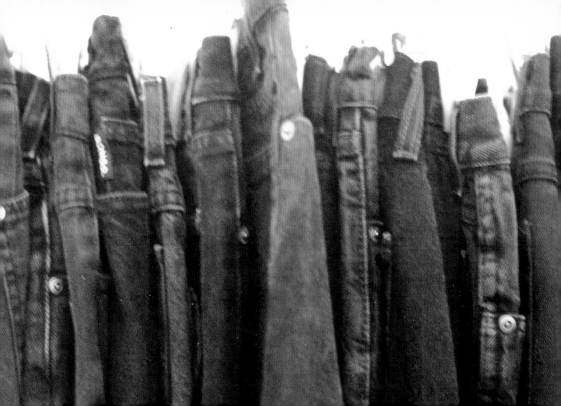

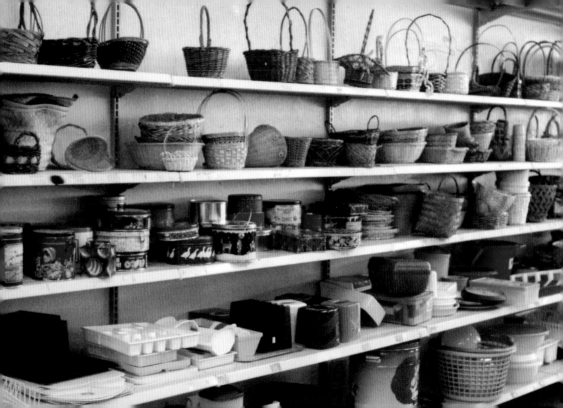

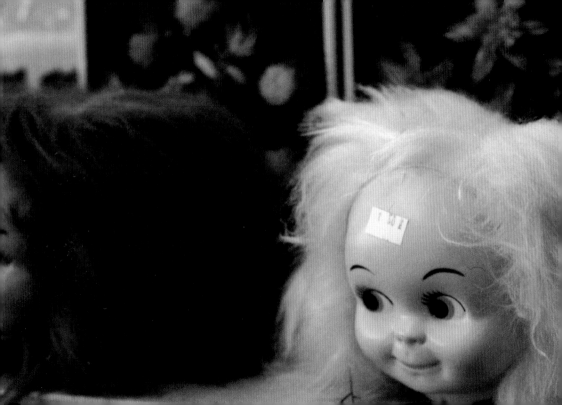

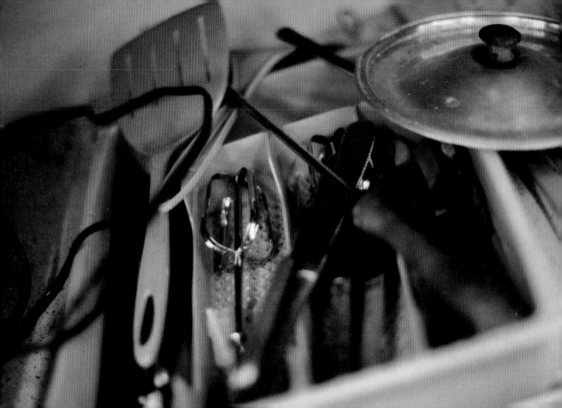

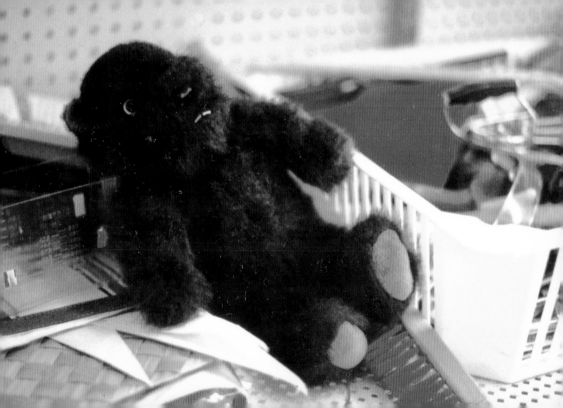

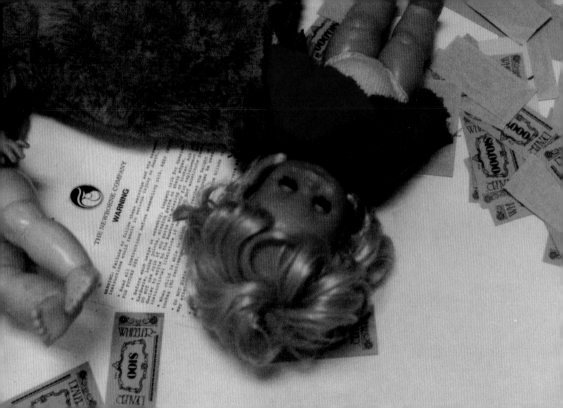

The use of a thing is precisely what makes it unique. Where it has been and how it got there and where will it go next is that which makes identical objects on a conveyor belt, later—once they have left the factory and then the store—very, very different. Mass-produced items gain status ("antique," "vintage," "one-of-a-kind") exclusively through enduring age, use, possession, ownership.

You know the stories of your own things: the pangs, the disgust, the sentimentality, the amusement you feel as you pack or throw away or pick up or dust. But what about everyone else's? The unwritten tomes of the undocumented stories, provenances, etymologies, of everything once owned or unowned, everything ever manufactured, produced, bought, sold, traded, found, or stolen?

A thrift store is an archive and a trove of material culture, an exhibition of shifts in taste and periods of popularity; an encyclopedia in objects of fad and fashion. Thrift stores everywhere are packed with physical objects that played as characters in everyone's story: birth, childhood, schooling, adulthood, death, and as mediaries, carriers of affection and obligation. The things of living.

When you are there, in a thrift store surrounded by just one of each of all old and used things, it is easy to believe that there is just one old soft orange and red striped velour loveseat, handsome dark wood arms and legs, springs pushing out the underneath stuffing, in all the world.

In a way, in terms of where it has been and where it will go, you are not wrong.

Emily K. Larned

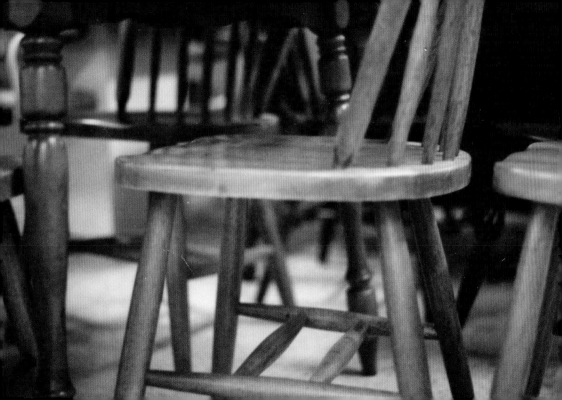

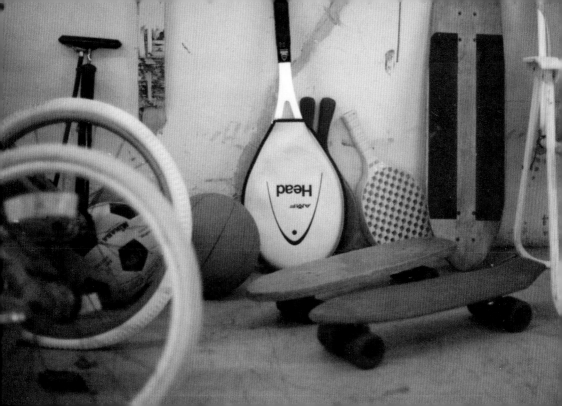

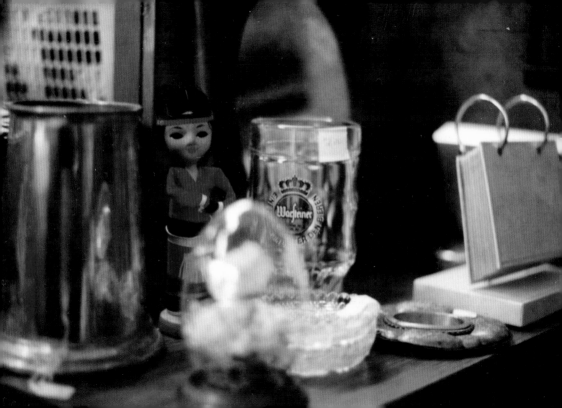

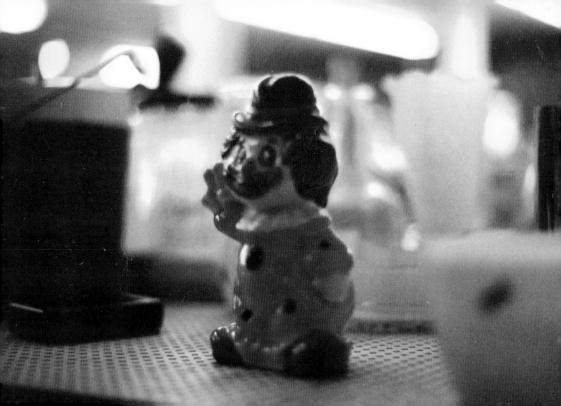

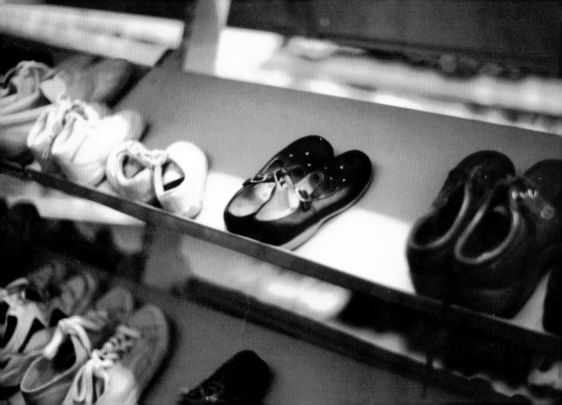

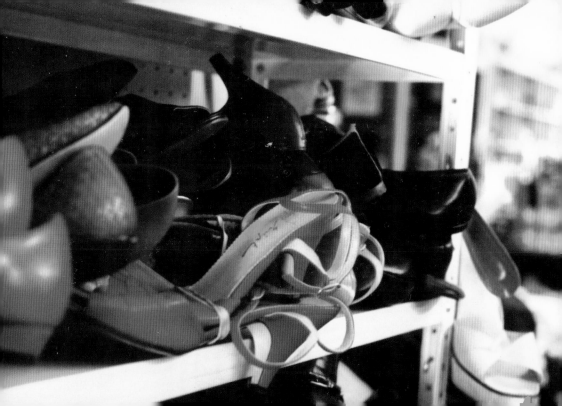

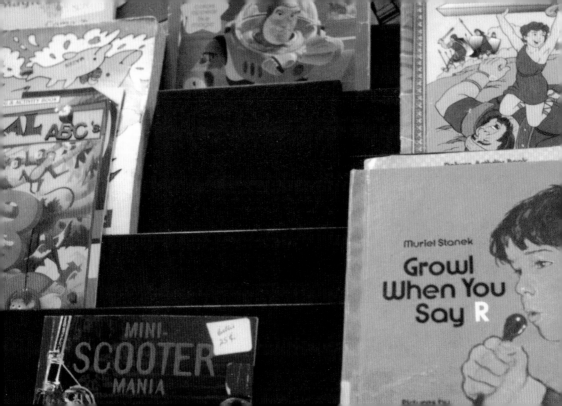

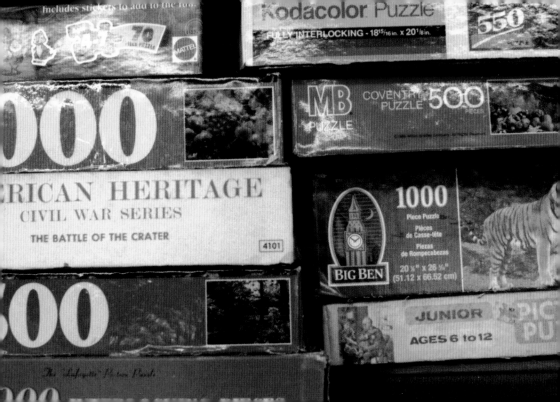

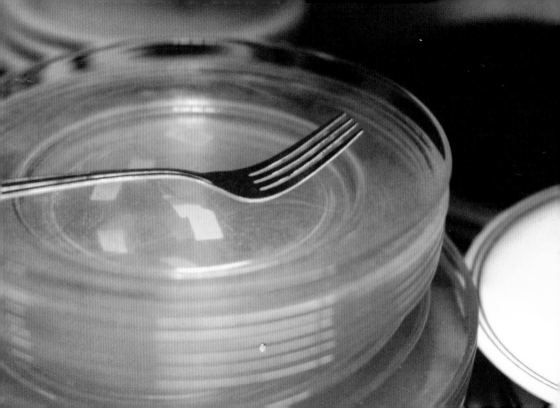

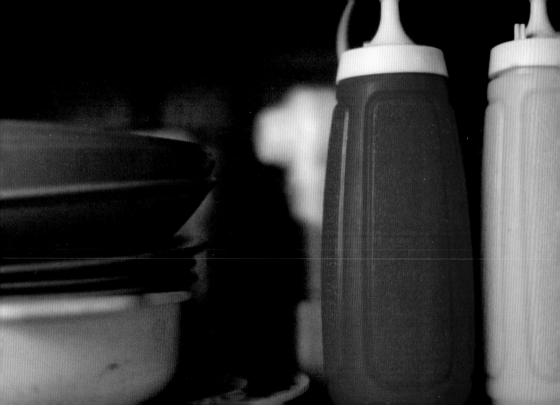

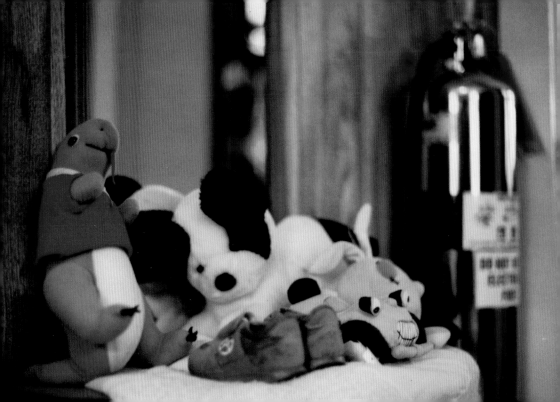

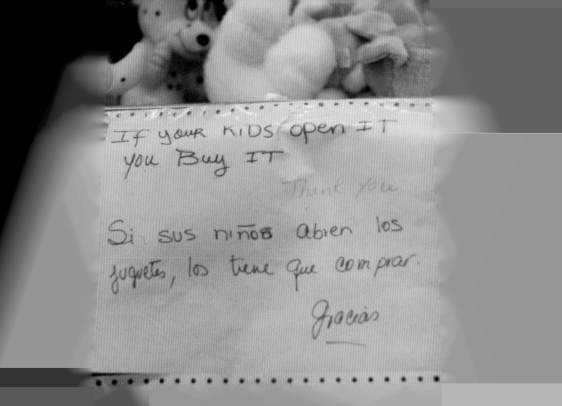

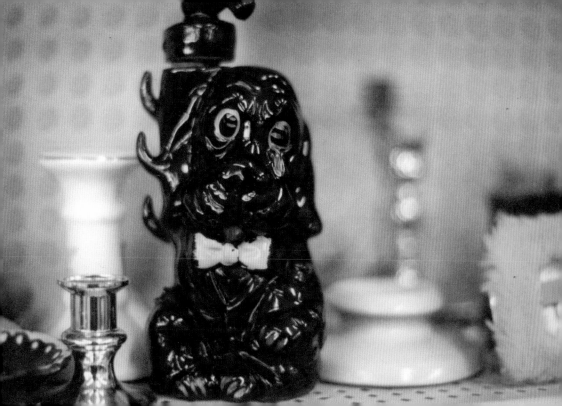

3 OZ

A thrift store is its own economic microcosm. It is subject to the personal preferences of the pricers, invisible but present, who never work the registers but rather sit in the back room of the store.

The pricers toil away: what is beautiful, what is quality, what is useful? Sweaters, no matter what their original cost, are priced between $1.99 and $5.99. Which gets what price? The shoppers too determine their own system, as do shoppers anywhere: how to judge what is of value. Of course, in a thrift store, there are two distinct groups of shoppers: those who choose to shop there, and those who must. Both types, however, ask themselves the same question: what is worth buying?

49

Twenty year old styles that are now again fashionable? This vase but not that one? Designer labels or, at the very least, name brands, no matter how dated the style or poor the condition? Items identical to those in the mall, at a fraction of the price? Or simply what fits, whether slacks, skirt, or couch?

Shoppers of any store exercise choice. Those in a thrift store, however, act as curators, selecting unique items among only unique items. A retail store guarantees and advertises a variety of products in a range of sizes, colors, fits, and finishes; in a thrift store, there is just one of each thing, take it or leave it. The item chooses you as much you choose it.

Emily K. Larned

No reading of Marx is necessary to understand that money is imaginary; the value of all commodities and currencies is dependent on nothing absolute. In a thrift store, an item's worth is determined not by its value in money, but exclusively by your interest in it. Thrift store prices have no relationship to quality or cachet. You get what you pay for no longer applies: when something costs $1.99, you can only get much more. By choosing something, you make it valuable.

Whatever you start with, it does not stay that way: a dress of great expense, once, is now no more costly than any other dress, whether from a discount store, a department store, a designer's boutique, or a mother's sewing machine. Any of these dresses are only of value to you if you like them, and if they fit.

In a thrift store, you determine the value of things, as imagined in your possession. You, in however a minute way, construct your own value system independent of the capitalist economy.

Emily K. Larned

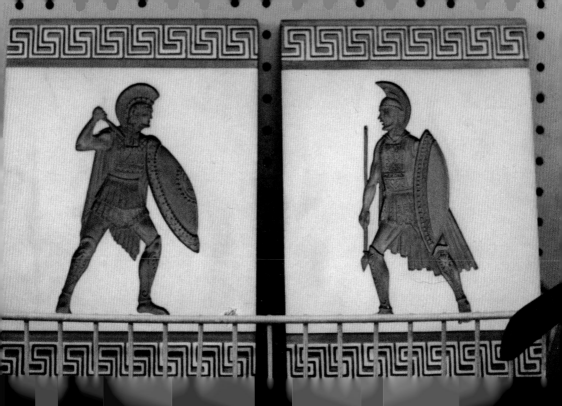

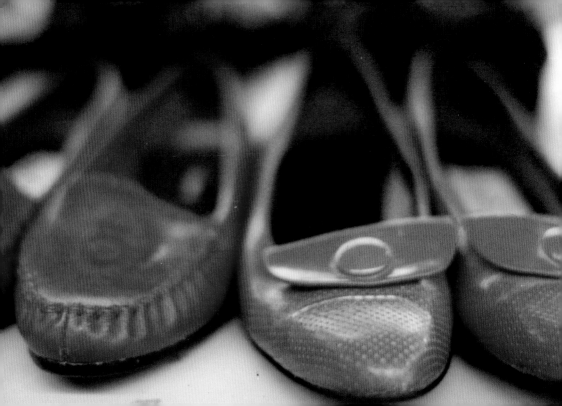

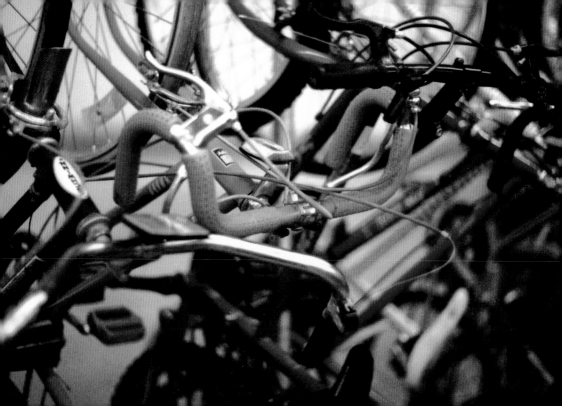

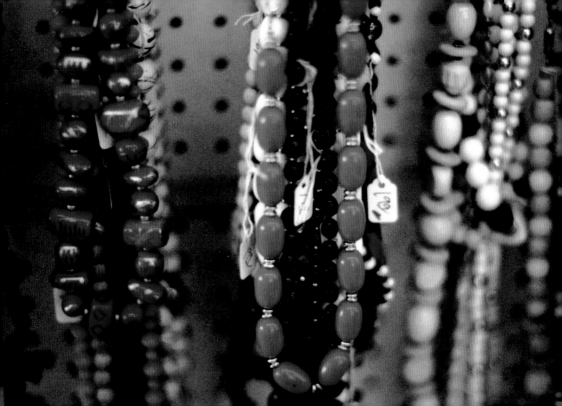

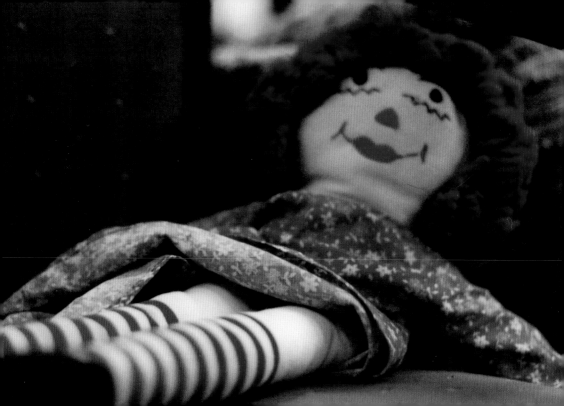

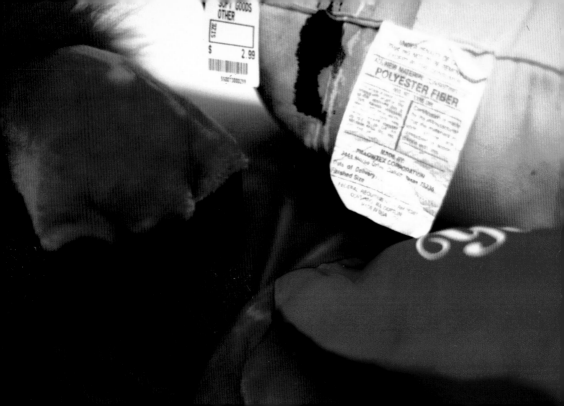

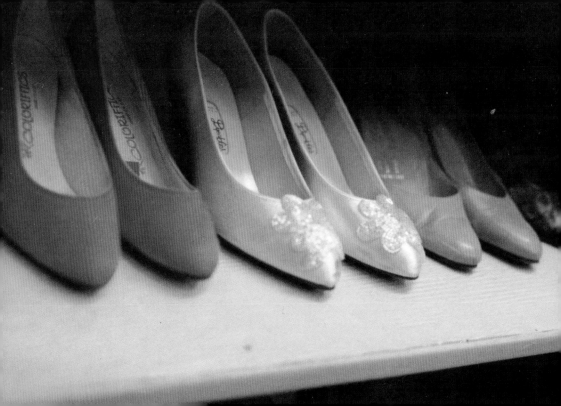

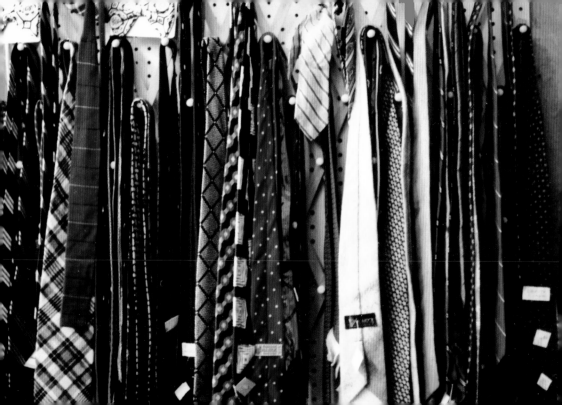

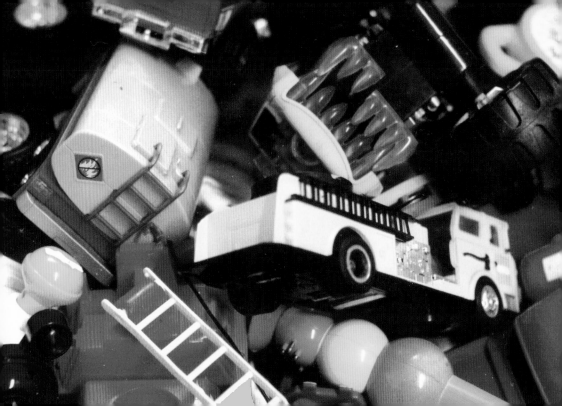

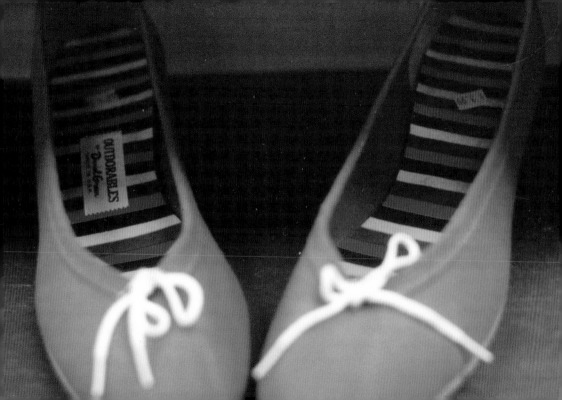

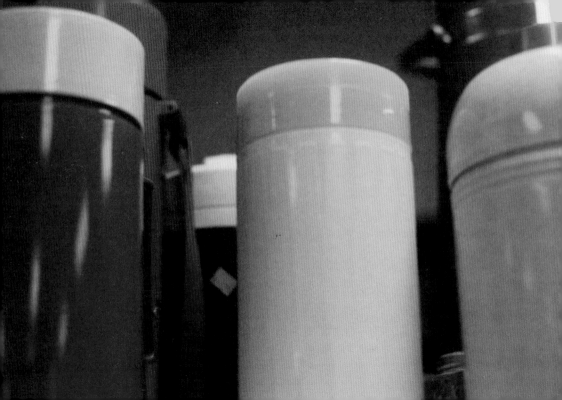

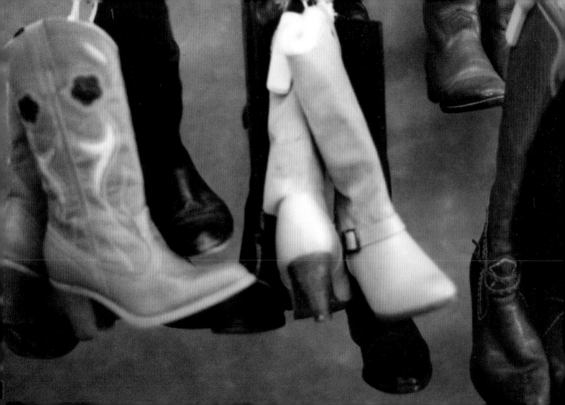

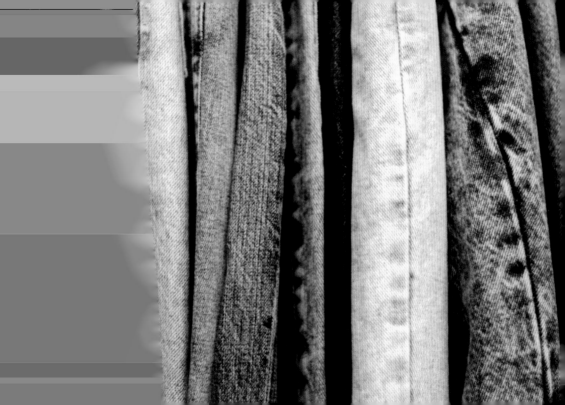

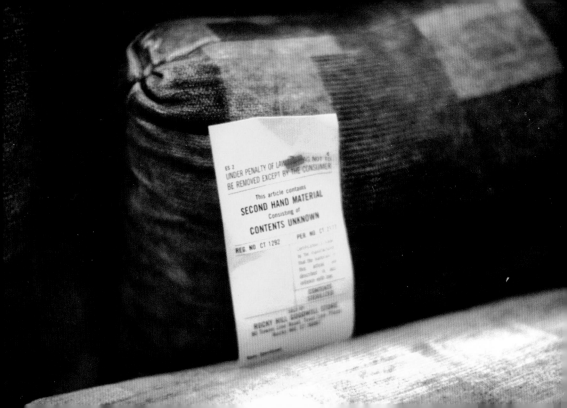

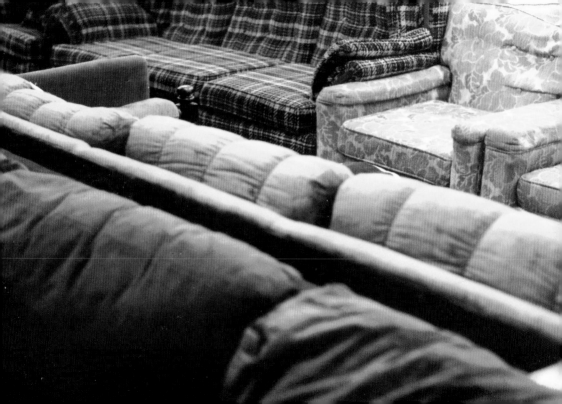

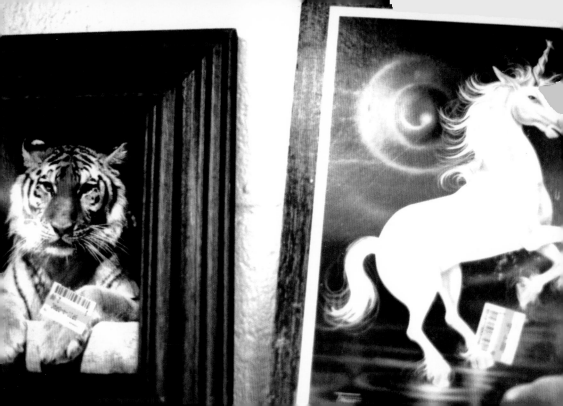

You can throw it out but short of burning it and scattering the ashes you will be hard pressed to destroy a thing. There is no real throwing out of anything, ever; you put it in the attic or out in the trash or out on the street but you are not throwing it out of existence. Things go on and on, taking up space, vibrating at the resonant frequency of their material make-up, in the dump, in the thrift store, still there in your apartment. Things go on being, on and on, whether or not they are in your possession. You cannot truly get rid of a thing. And there are so many things.

71

U&L percussive presets

| electric piano | clavi | rocker | jazz guitar | banjo |
| acoustic piano | harpsi chord | vibra phone | acoustic guitar | steel drum |

harmonic control

volume

Voice Setting Computer

| I | II | III | IV |
| cancel | V | VI | VII |

U&L orchestral preset

| trum pet | french horn | accor dion | synthe brass |
| trom bone | brass pizzes | clari net | soft brass |

u tab voices | L tab voices | slow

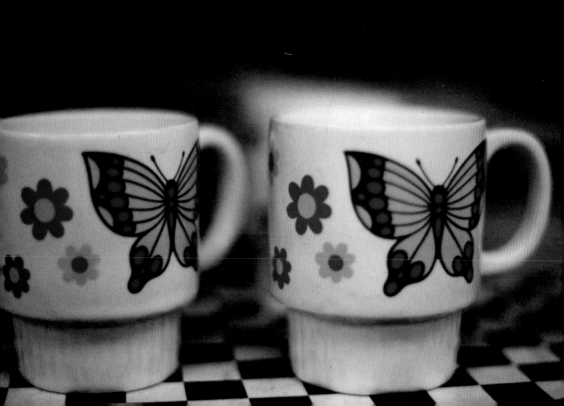

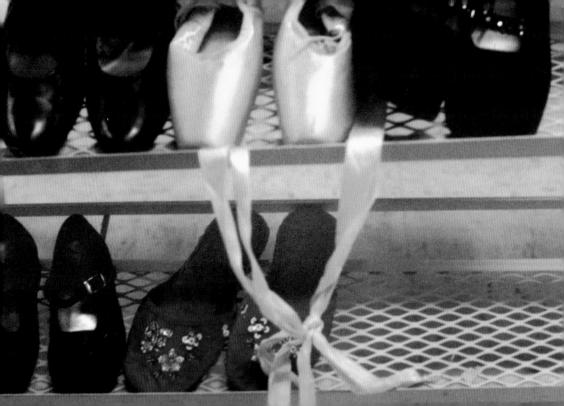

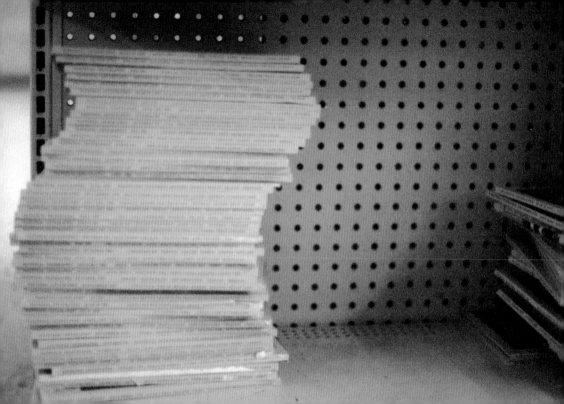

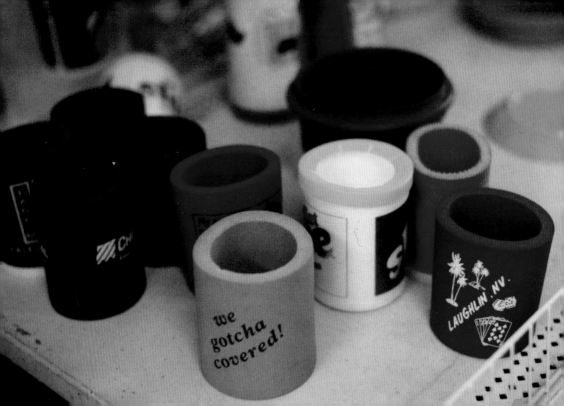

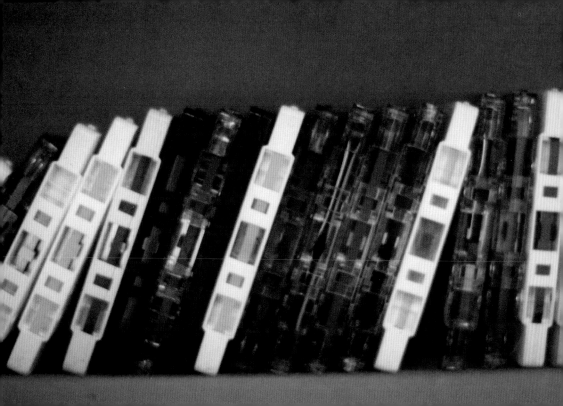

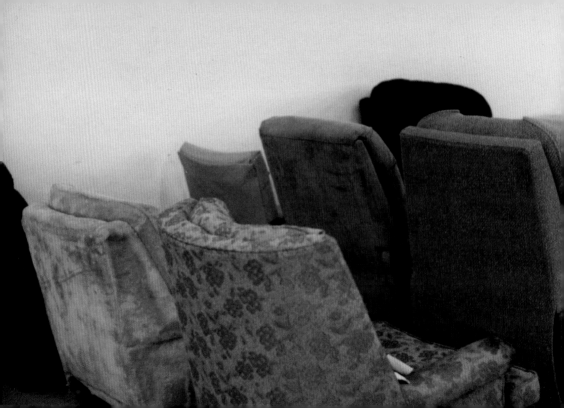

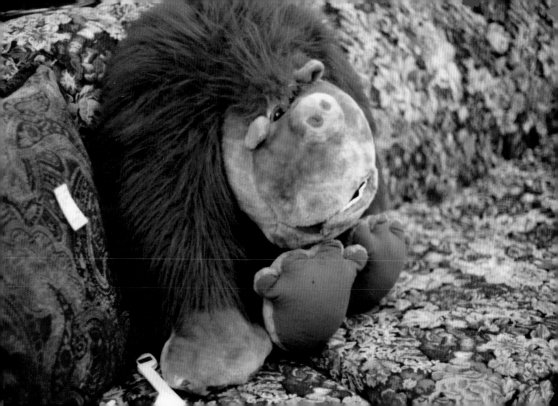

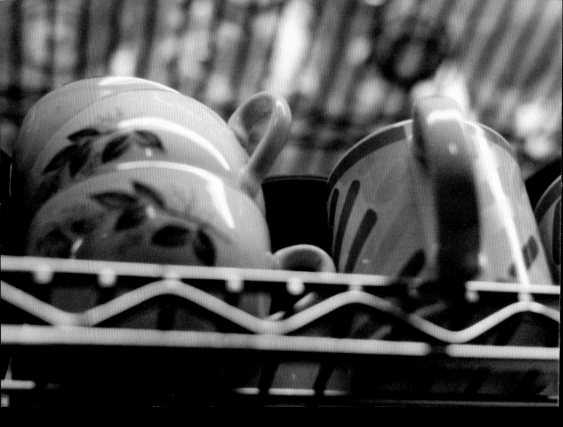

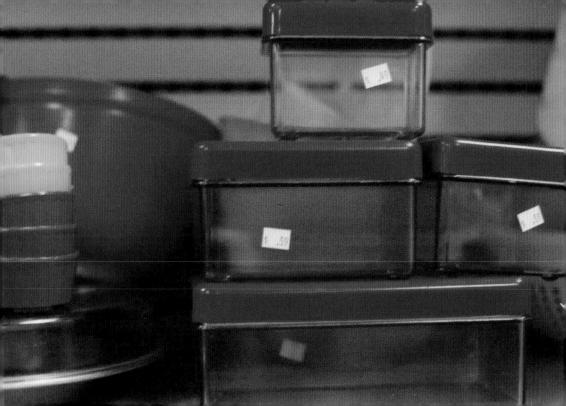

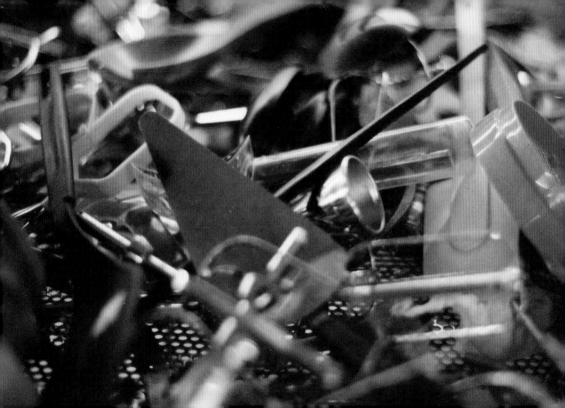

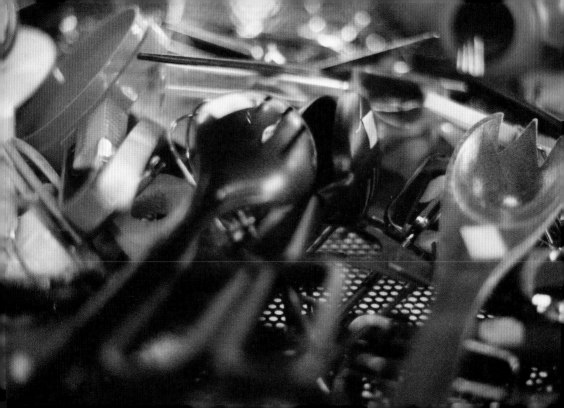

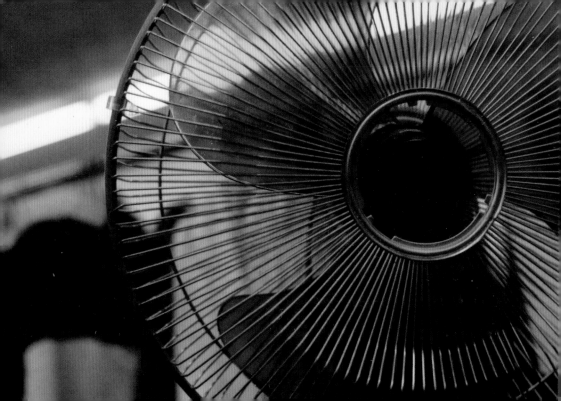

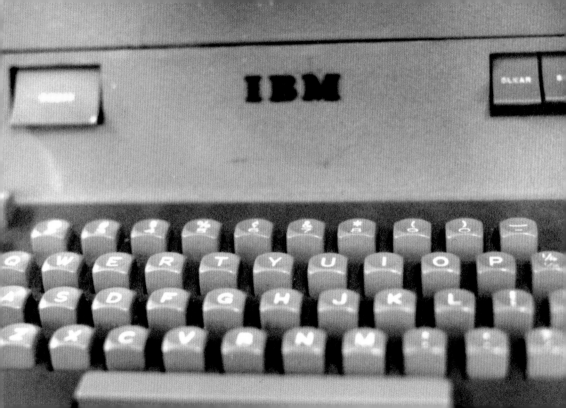

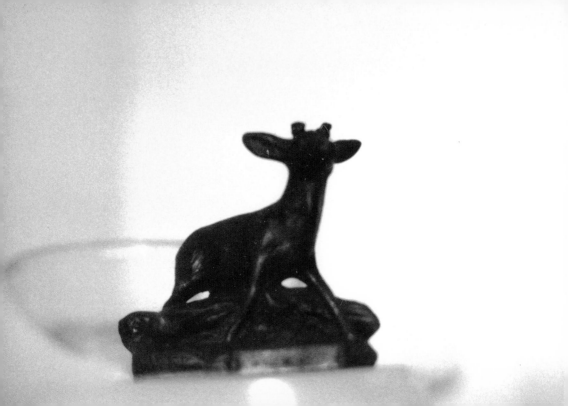

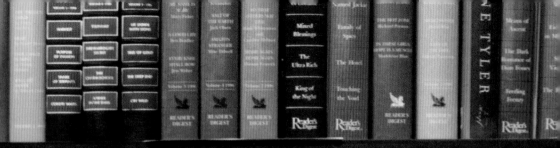

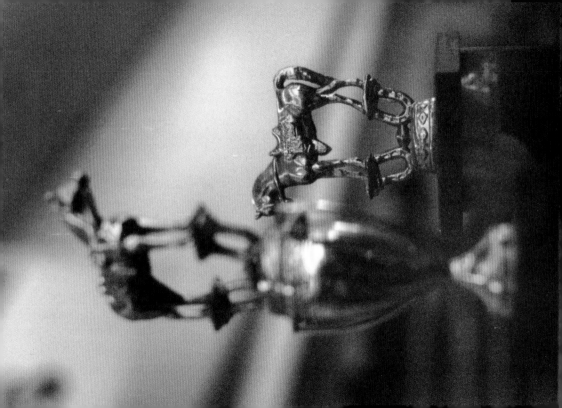

The 35 mm photographs were taken with a manual 1972 Honeywell Pentax between 1995–2004. Scenes depicted take place in Goodwills, Salvation Armies, Savers, Thrift Towns, and independent thrift shops across America in the fine cities and towns of Albuquerque, Banksville, Danbury, Los Angeles, Middletown, New Haven, New York, Portchester, Rocky Hill, Stamford, and Topeka. Many thanks to these locales for their hospitality and their great stuff. Thanks also to my father, Michael, for giving me his old camera in 1994; and to my mother, Beazie, for taking me to my first thrift shop, the Rummage 'Round, in 1989.

Emily K. Larned is an avid thrifter, an esteemed book artist, and the Vice President of Booklyn, a not-for-profit artist alliance. Her handmade artist books have been included in many international exhibitions and have been collected by over fifty public collections, including MoMA, the Smithsonian, the Library of Congress, Tate Britain, Walker Art Center, and the Getty.

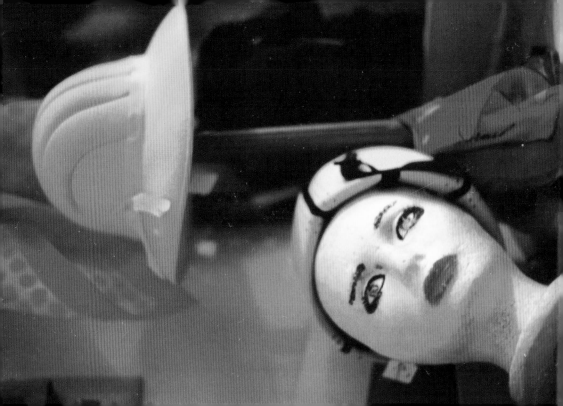

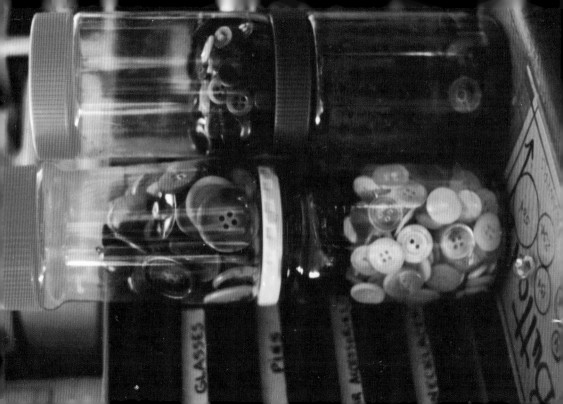

PLEASE
RING BELL
FOR
CASHIER

Copyright 2006 *by* Emily K. Larned
ALL RIGHTS RESERVED

No part of this book may be used or reproduced
in any manner without written permission of the
publisher. Please direct inquires to:
Ig Publishing
178 Clinton Avenue
Brooklyn, NY 11205
www.igpub.com

10 digit ISBN: 0-9752517-5-9
13 digit ISBN: 978-0-9752517-5-1

COVER & TEXT DESIGN: Pure+Applied
Printed in China

Thrift Store was orignally published in 2003 as a
limited edition artist book by Red Charming.